How Romantic, Charlie Brown

Selected cartoons from
THE WAY OF THE
FUSSBUDGET IS NOT
EASY, Vol. II

Charles M. Schulz

CORONET BOOKS
Hodder and Stoughton

PEANUTS comic strips
by Charles M. Schulz

Copyright © 1983, 1984 by United
Feature Syndicate, Inc.

First published in the United States of
America 1988 by Ballantine Books

Coronet edition 1988

This book comprises a portion of THE
WAY OF THE FUSSBUDGET IS NOT
EASY and is reprinted by arrangement
with Henry Holt and Company.

British Library C.I.P.

Schulz, Charles M. (Charles Monroe),
1922–
 How romantic, Charlie Brown :
 selected cartoons from The way of
 the Fussbudget is not easy.
 Vol. 2
 I. Title
 741.5'973

 ISBN 0 340 42847 3

Printed and bound in Great Britain
for Hodder and Stoughton
Paperbacks, a division of Hodder and
Stoughton Ltd., Mill Road,
Dunton Green, Sevenoaks, Kent
TN13 2YA.
(Editorial Office: 47 Bedford Square,
London WC1B 3DP) by
Cox & Wyman Ltd., Reading.

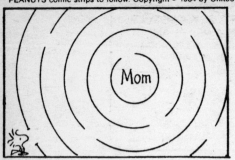

BIRDS AREN'T LIKE DOGS, FOR INSTANCE...
DOGS ARE VERY SENTIMENTAL AND
LOVING WITH A STRONG SENSE OF FAMILY...
YOU KNOW WHAT I MEAN?

BIRDS ARE WEIRD..BIRDS DON'T CARE...
ONCE THE KIDS LEAVE THE NEST, THAT'S IT!
OFF YOU GO! GOOD LUCK! BREAK AN EGG!

HA HA HA HA!!
"BREAK AN EGG!"
THAT'S A GOOD ONE!

boot!

I THOUGHT IT WAS
A GOOD ONE..

ALL RIGHT, TURN AROUND AND PUT YOUR HANDS UP!

GOT HIM AGAIN!

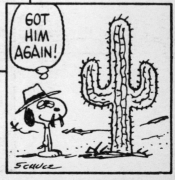

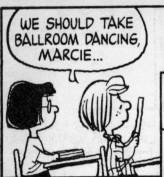

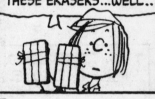

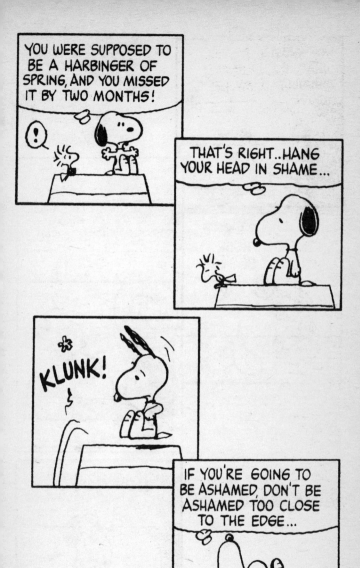

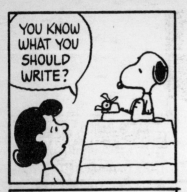

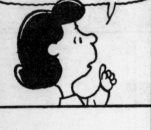

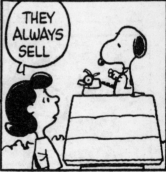

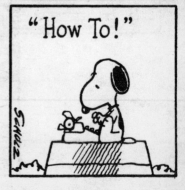

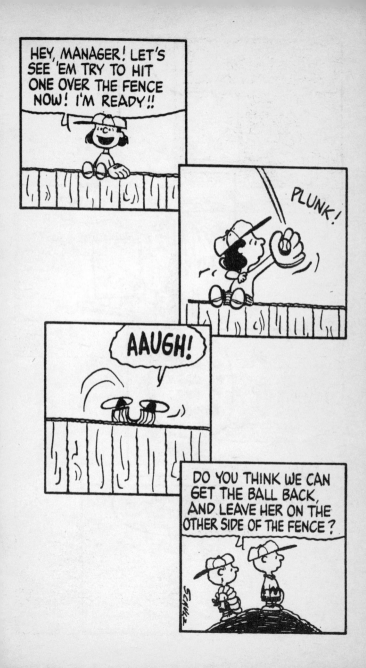

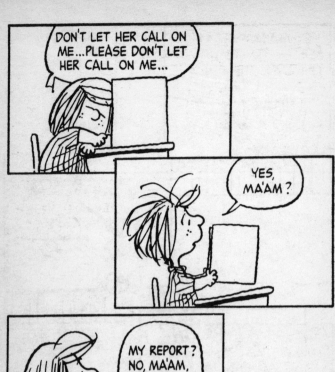

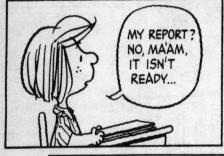

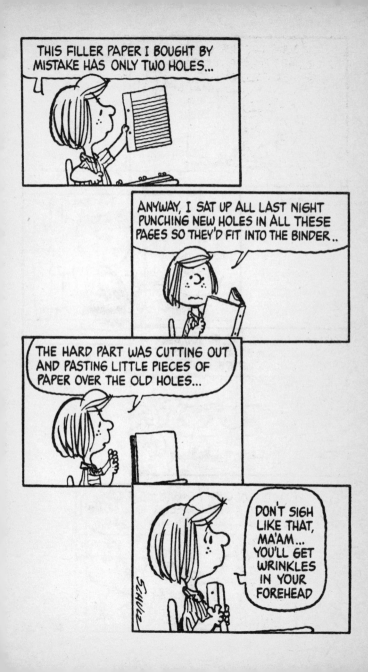

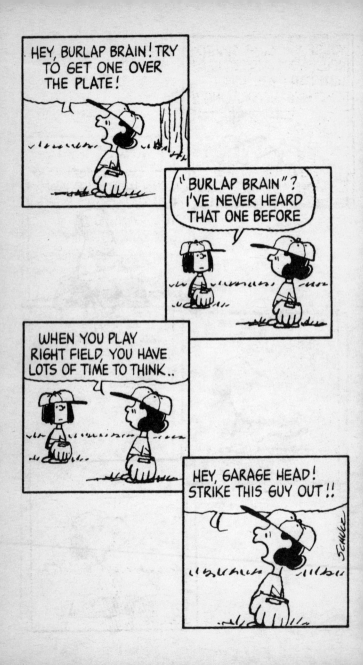

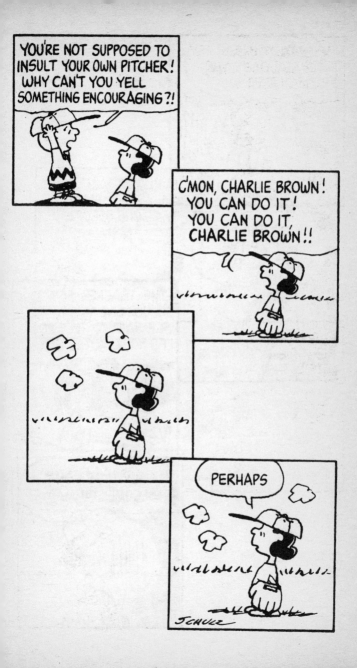

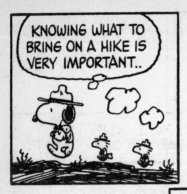

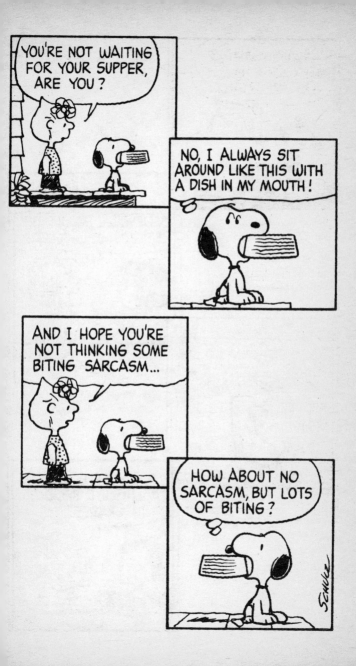

TODAY IS REPORT CARD DAY, MARCIE...TODAY WE FIND OUT IF WE MOVE UP A GRADE...

DO YOU WANT ME TO PASS OUT THE REPORT CARDS, MA'AM?

OR EMPTY A FEW WASTEBASKETS?

WASH YOUR CAR?

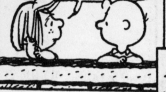

I FAILED, MARCIE! I WON'T BE IN YOUR CLASS NEXT YEAR..YOU WON'T BE SITTING BEHIND ME...

WHO'S GOING TO WAKE YOU UP WHEN YOU FALL ASLEEP AT YOUR DESK?

WHO'S GOING TO TAKE THE LOOSE-LEAF BINDER OFF YOUR HEAD WHEN IT GETS TANGLED IN YOUR HAIR?

WHEN WE HAVE TESTS, WHO'S GOING TO GIVE YOU ALL THE ANSWERS?

YOU NEVER GAVE ME ANY ANSWERS!

GUESS WHAT, CHARLES.. I GOT STRAIGHT "A'S" ON MY REPORT CARD THIS TERM...

PEPPERMINT PATTY FAILED EVERY SUBJECT...NOW, HER DAD IS TAKING HER TO EUROPE FOR THE SUMMER..

YOU KNOW WHERE I'M GOING? NO PLACE!

EVERY TIME I TRY TO FIGURE THAT OUT I GET DIZZY!

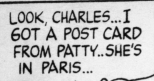

LOOK, CHARLES...I GOT A POST CARD FROM PATTY..SHE'S IN PARIS...

Dear Marcie,
The trip over was fun. We have a nice place to stay.

I'm already doing pretty good with the language.

BONJOUR, KID!

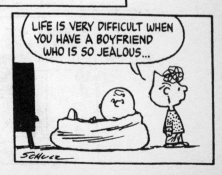

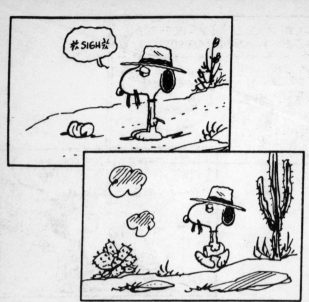

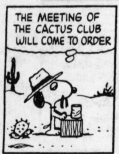

Dear Chuck,
Well, your ol' friend Patty is here in Paris.

Show Snoopy this picture of me drinking root beer in a sidewalk cafe.

I REMEMBER THAT PLACE..I WAS THERE IN 1918!

THE MEETING OF OUR LOCAL CACTUS CLUB WILL COME TO ORDER...

WE WILL NOW HEAR THE TREASURER'S REPORT

WE DON'T HAVE ANY MONEY..WE'VE NEVER HAD ANY MONEY AND WE'RE NEVER GONNA HAVE ANY MONEY!

I ALWAYS HATE THE TREASURER'S REPORT...

SCHULZ

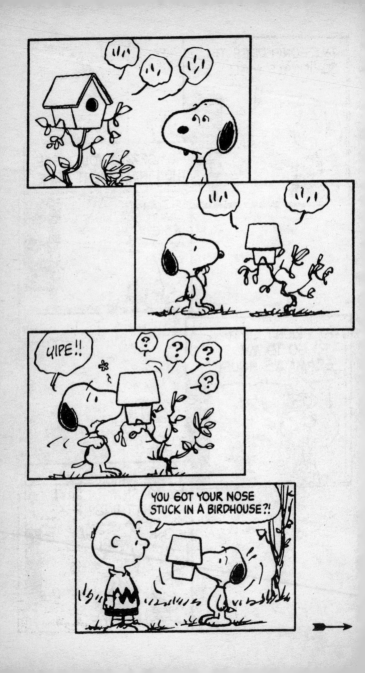

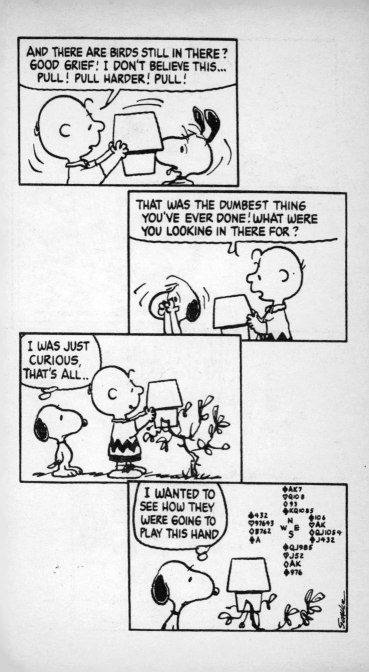

GEE, I DON'T KNOW.. I REALLY THINK YOU'D BETTER GO WITHOUT ME..THANKS ANYWAY...

·SIGH·

ACTUALLY, NOTHING COULD INTEREST ME LESS THAN GOING TO A SEED TASTING!

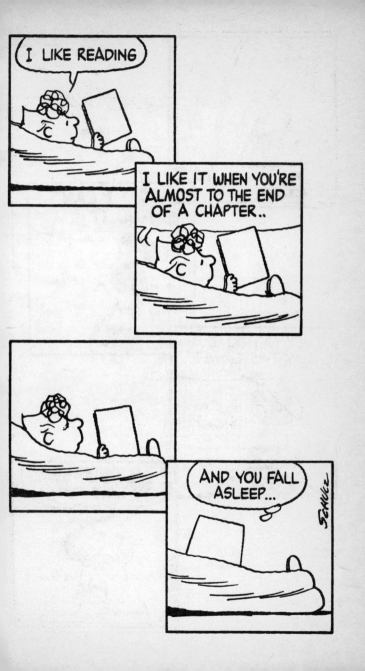

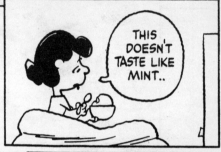

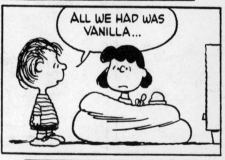

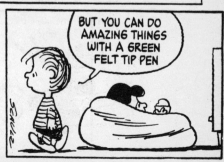

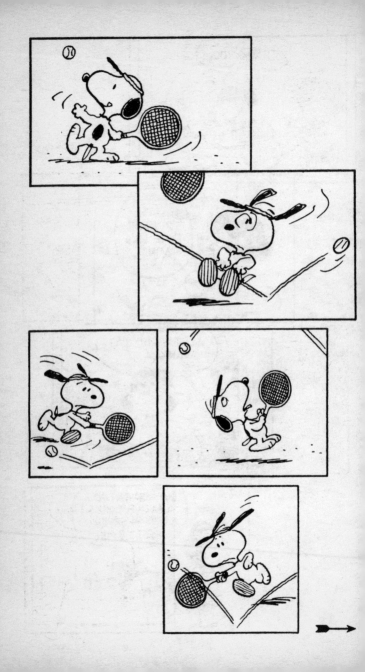

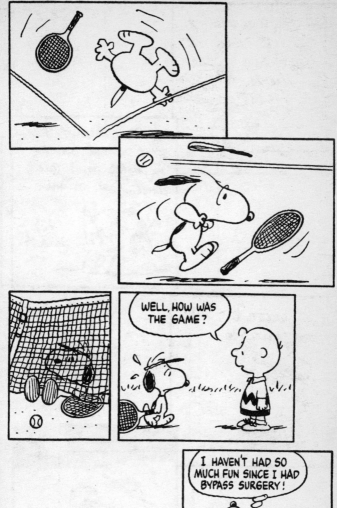

Dear Brother Snoopy,
It gets cold at
night here on the
desert.

I have heard that
some animals sleep
in holes so I tried
that last night.

It wasn't very
comfortable.

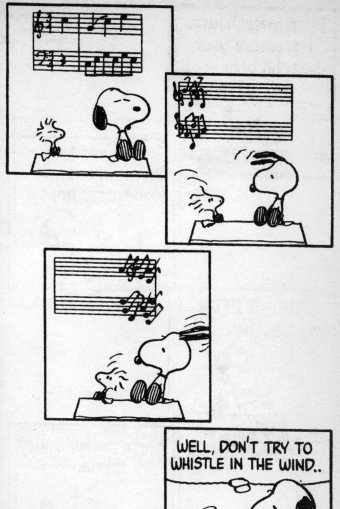

Dear Sweetheart, I treasure your last letter.

I have read it over and over. It made me so happy.

Only one little part bothered me...

Where you misspelled my name.

WHY DO FILLING STATION ATTENDANTS WASH YOUR WINDSHIELD EVEN IF IT'S ALREADY CLEAN?

IT GIVES THEM A CHANCE TO BREAK YOUR WINDSHIELD WIPERS!

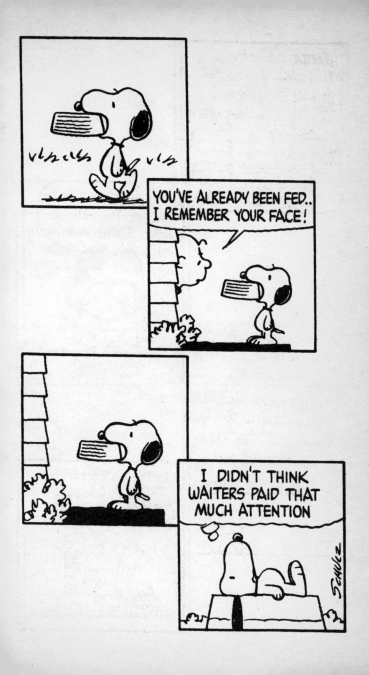

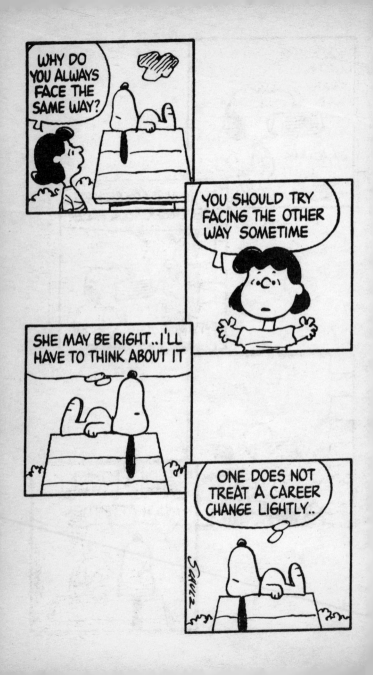

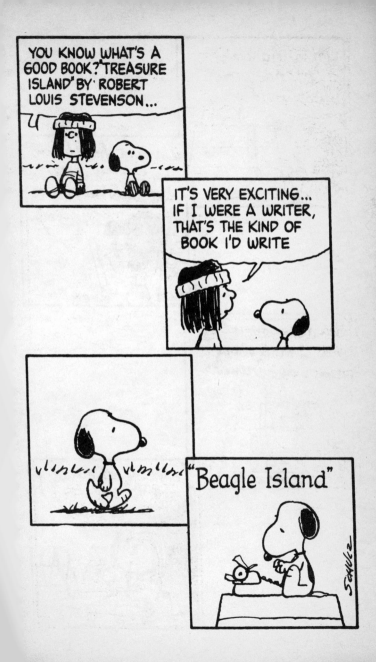

Dear Marcie,
We are now back in Paris.

We just had lunch in a very nice little restaurant.

You'd be proud of me. I'm learning to order in French.

GARÇON, JUNK FOOD, S'IL VOUS PLAÎT!

IT'S FUNNY...JUST LOOKING AT AN AD FOR A HOTEL THAT SHOWS AN EMPTY LOBBY MAKES ME FEEL LONELY

Happy Birthday, Amy!

I DON'T WANT TO GROW UP, AND LEAVE HOME, AND TRAVEL AND LIVE IN HOTELS...

YOU HAVE TO.. YOU CAN'T STAY HOME FOREVER!

AND AS SOON AS YOU LEAVE, I GET TO MOVE INTO YOUR ROOM!

SEE THOSE LITTLE BIRDS UP THERE CHASING THAT BIG BIRD? THAT'S WHAT YOU GUYS SHOULD PRACTICE

I'LL BE THE BIG BIRD WHO COMES FLYING IN, AND YOU PRACTICE ATTACKING ME...

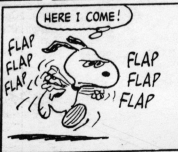

HERE I COME!

FLAP
FLAP
FLAP

FLAP
FLAP
FLAP

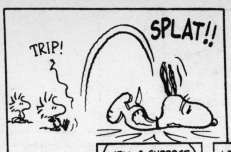

SO I DON'T KNOW WHICH PROGRAM TO WATCH... MAYBE I'LL JUST READ A BOOK, WHO KNOWS? I ALSO HAVE A LOT OF PHONE CALLS TO MAKE

WHEN SCHOOL STARTS AGAIN, THERE'LL BE OTHER THINGS TO DO, I SUPPOSE..LIFE GOES ON, I GUESS, DOESN'T IT?

WELL, IT'S BEEN NICE TALKING TO YOU, CHARLIE BROWN..

THANK YOU..IT'S BEEN NICE LISTENING

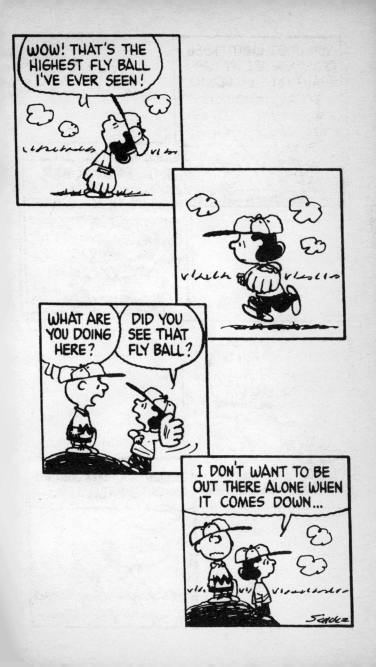

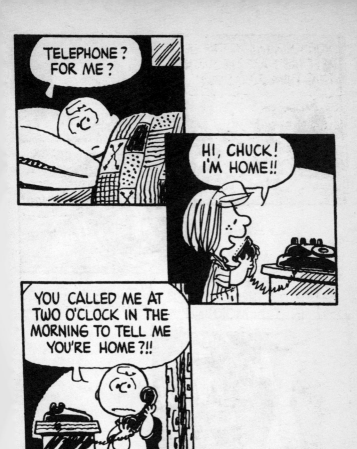
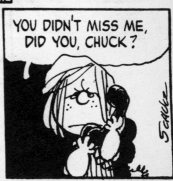

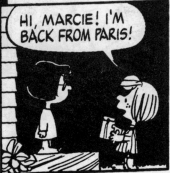

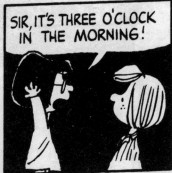

SEE, MARCIE? HERE I AM STANDING IN FRONT OF THE EIFFEL TOWER...

SIR, I DON'T WANT TO LOOK AT YOUR VACATION PICTURES AT THREE O'CLOCK IN THE MORNING!

I HAVE JET LAG, MARCIE.. I CAN'T SLEEP...I'M STILL ON PARIS TIME... I'M READY FOR LUNCH...

GOOD NIGHT, SIR

PEANUT BUTTER ON A CROISSANT SOUNDS GOOD...

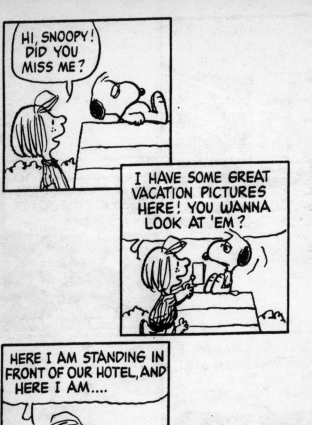
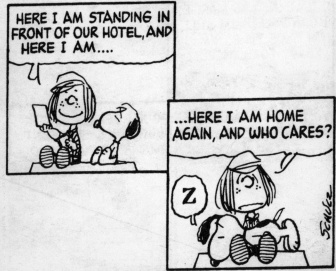

THIS IS MY FAVORITE TIME OF DAY...

ONE OF THE GREAT JOYS OF LIFE IS SHARING A MEAL AROUND A CAMPFIRE...

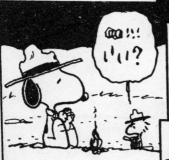

NO, CONRAD, I DON'T KNOW HOW YOU KEEP THE BUTTER FROM FALLING OFF THE BREAD STICKS...

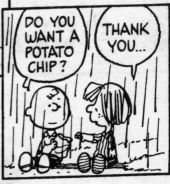

I BROUGHT SOME OF MY VACATION PICTURES FOR YOU TO SEE, SCHROEDER, BUT I GUESS YOU'RE BUSY...

WHY DON'T I JUST LEAVE THEM HERE, AND YOU CAN LOOK AT THEM LATER?

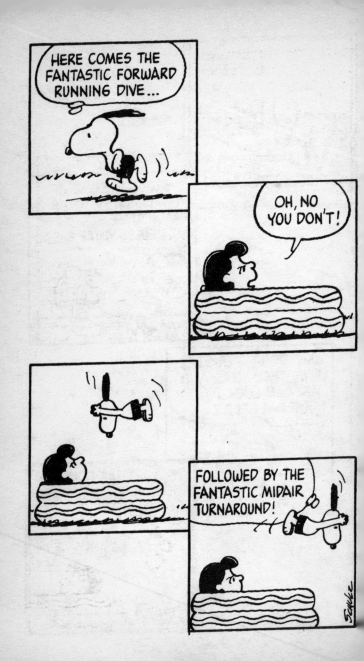

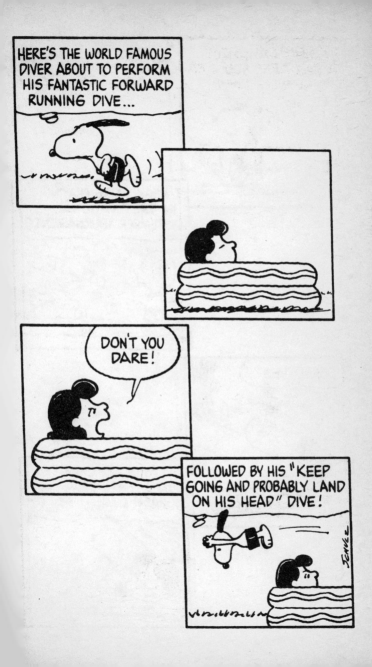

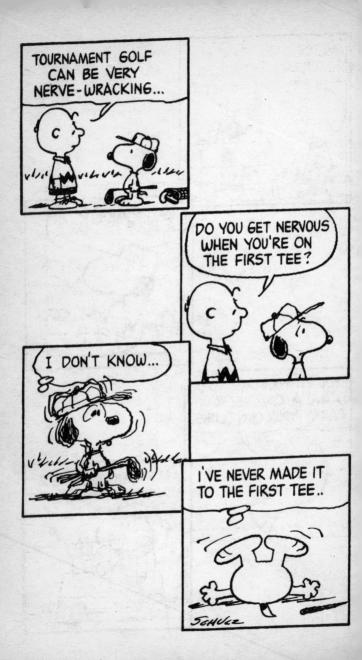

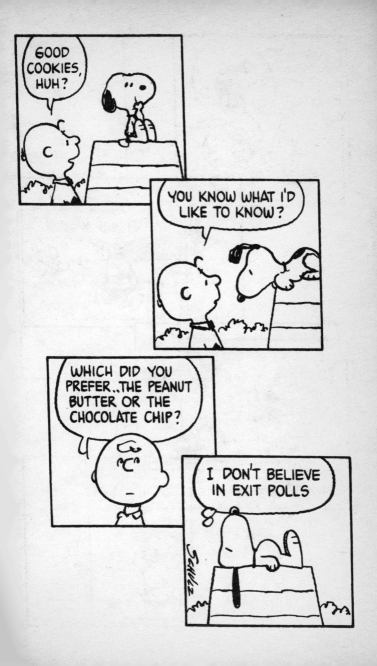

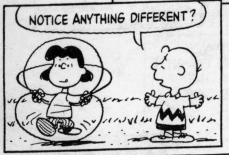

NOTICE ANYTHING DIFFERENT?

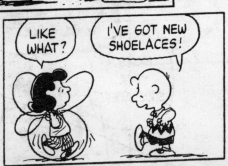

LIKE WHAT?

I'VE GOT NEW SHOELACES!

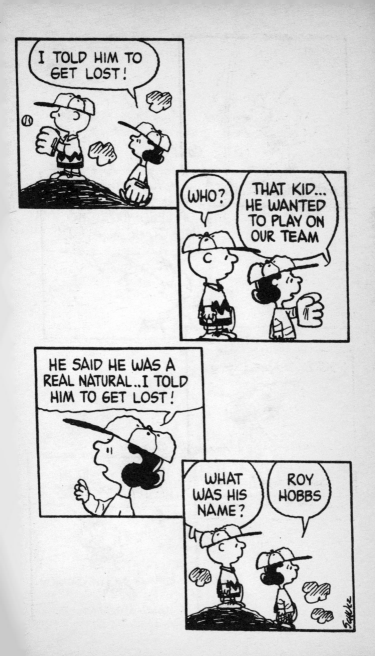

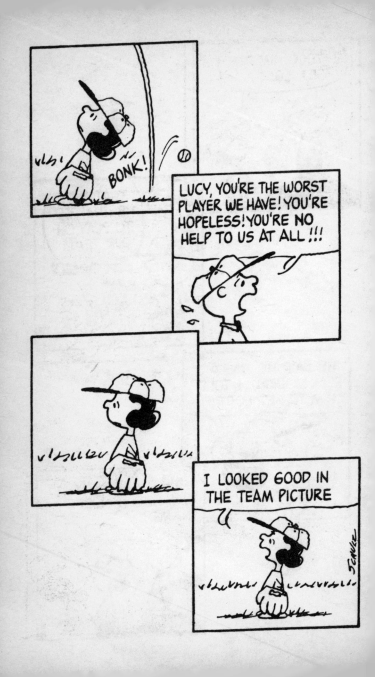

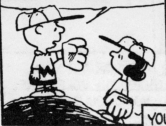

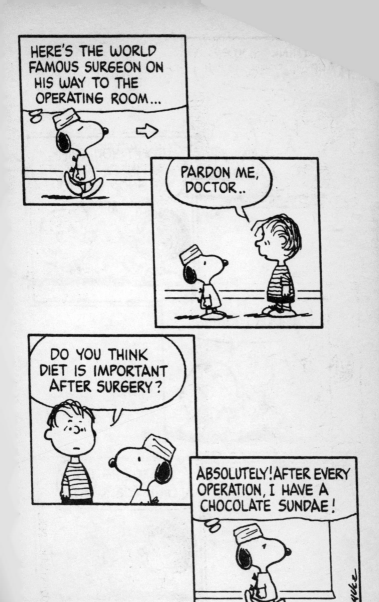

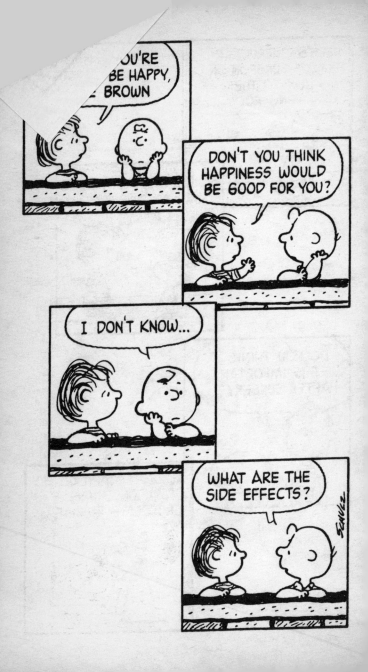

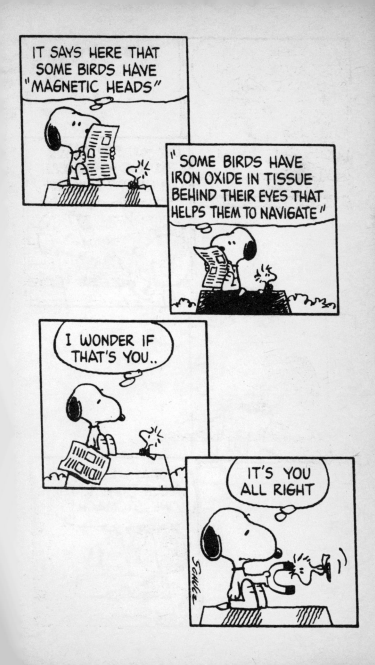

DID YOU SEE THAT?
I BROUGHT YOUR SUPPER
OUT ON ONE FINGER!

AND I ATE THE
WHOLE THING WITH
ONE STOMACH!

SCHOOL STARTS SOON, FRANKLIN, BUT WE WON'T BE IN THE SAME CLASS THIS TERM...

I'M GONNA MISS YOU, PATRICIA..

I REMEMBER ONCE I THOUGHT I HEARD A JET FLYING OVER OUR SCHOOL..I TURNED AROUND, AND IT WAS YOU SNORING...

DON'T COUNT ON ME SPEAKING TO YOU AT THE HIGH SCHOOL PROM, FRANKLIN!

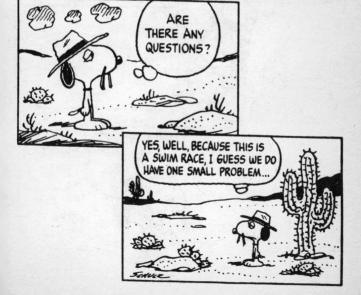

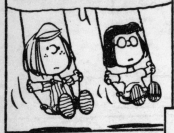

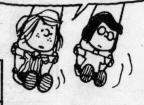

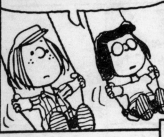

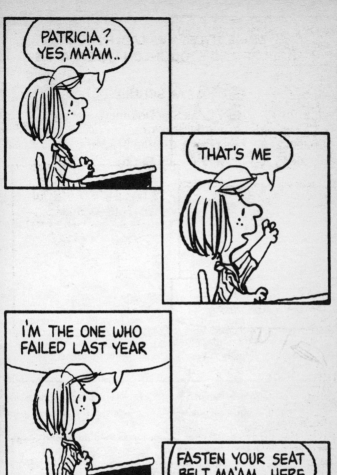
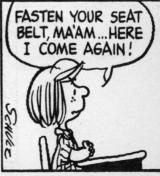

MORE TITLES AVAILABLE FROM
HODDER AND STOUGHTON PAPERBACKS

CHARLES M. SCHULZ

All these books are available at your local bookshop or newsagent, or can be ordered direct from the publisher. Just tick the titles you want and fill in the form below.

Prices and availability subject to change without notice.

Hodder & Stoughton Paperbacks, P.O. Box 11, Falmouth, Cornwall.

Please send cheque or postal order, and allow the following for postage and packing:

U.K. – 55p for one book, plus 22p for the second book, and 14p for each additional book ordered up to a £1.75 maximum.

B.F.P.O. and EIRE – 55p for the first book, plus 22p for the second book, and 14p per copy for the next 7 books, 8p per book thereafter.

OTHER OVERSEAS CUSTOMERS – £1.00 for the first book, plus 25p per copy for each additional book.

Name ..

Address ..

..